FOUR HAIKUS SAKE

By

Ben Norman. Dan Broadbent.

Peet Singleton. Thom Norman.

An introduction.
By a girl on the subject.
Of four men's haiku.

 Virginia Reina.

Ben Norman: Younger sibling of Thom Norman, was banished from the scuttle fields of Barnsley at a young age for possessing an unauthorized stash of Pogs. He now resides in Wakefield town, where he writes short stories for the disabled. He began writing haikus as a way to reach those with a shorter attention span and to make his job easier. When not writing haikus, he enjoys pondering concepts over a good cheese.

Dan Broadbent: By day he's coated with a thin layer of SPF 50. By night he's a funky diva. Hobbies include excessive extreme ping pong and long boarding. Ginger by name but not by nature, Dan has been writing Haiku for around a year now, born in Lancashire, raised in Yorkshire and currently resides in Dorset studying BA Fine Art.

Peet Singleton: 31 year old drainpipe cleaner from Nottingham, England. Discovered the art of haikuism on a night out at the age of ten. In his spare time he uses his voice to leave Thom Norman voicemails.

Thomas Norman: Born in the coal fields of Barnsley, where he remains to this day, sorting and scuttling. He was expelled from play school for imitating Tommie Smith's 1968 Olympics Black Power salute in the wrong context. Thomas first discovered haikuism on a controversial solo corporate Go-Karting experience day. In his spare time he eats meat and organises odd socks.

Lock up your children!
"She's quite sexy for a child."
Daniel Broadbent.
 Ben Norman.

Get off your high horse.
We share the same colour blood.
We are all human.

 Dan Broadbent.

God's bollocks made us!
He shat out our souls and smiled.
He wants His stink back!
 Peet Singleton.

Have faith in your guts.
Unless they are on the floor.
Take Imodium.

 Thom Norman.

Golden flowing locks.
Sooty face, pickaxe and limp.
2-Stroke power Dad.

 Ben Norman.

I am colour blind.
I only see shades of grey.
True equality.

 Dan Broadbent.

I'm gonna go dump!
Then wipe me hand with me bum.
Pass the toilet roll!

 Peet Singleton.

Fate is a cop out.
You wrangle your own balls bitch.
Go forth and conquer.

 Thom Norman.

Sweet slap of codeine.
Beer, blood, sweat, chicken, sick, cigs.
We are Nocturnal.

 Ben Norman.

Just killed a kestrel.
It flew into the windscreen.
Not a clever bird.

 Dan Broadbent.

I have stomach ache!
The things I do to myself.
Two pound coin I ate!

 Peet Singleton.

Slippery when wet.
Good job I use protection.
This time anyway.
 Thom Norman.

Felix Baumgartner.
Big balls and shitty undies.
I'm glad you're not dead.
 Ben Norman.

Post-Christmas sales shop.
Individuality.
No longer exists.
 Dan Broadbent.

Fuck, I weigh more now.
Two pound coin, plus gravity.
No more eating those!

 Peet Singleton.

Fuzzy head, void soul.
A rape victim on Prozac.
Vacant but happy.

 Thom Norman.

Semiology.
Signifier plus Signified.
Then becomes a sign.

Ben Norman.

Be true to yourself.
Give everything you have.
Strive to be complete.

 Dan Broadbent.

Rewind time please God.
Last night was a big write off.
Friendships deleted!

 Peet Singleton.

Photograph the lot.
A tourist in one's own life.
Oh, how enthralling.

 Thom Norman.

The sharp white powder.
Harsh brain-slapping twang.
Also known as salt.

 Ben Norman.

Laws of attraction.
Can easily be broken.
True inner beauty.

 Dan Broadbent.

Gotham's reckoning.
Why does he loathe Batman so?
He dealt a low blow!
 Peet Singleton.

Happy-Go-Lucky.
The graceful simplicity.
One that is two down.

 Thom Norman.

Give your words to me.
Let's see if I can't break them.
Your walls are like glass.

 Ben Norman.

First line is easy.
Second requires a bit more.
Third is when you know.

<div align="right">Dan Broadbent.</div>

Bamboo Amnesty.
Hand those nasty weapons in!
You will not be charged.

 Peet Singleton.

I feel overjoyed.
When I listen to your words.
Well done lads, nice hair.

 Thom Norman.

Carbon waste today.
He's buried six feet under.
Diamonds tomorrow.

 Ben Norman.

Living is knowing.
Existing is respiring.
Dying happens once.

 Dan Broadbent.

Tiny Chinese boy.
I want to be your pappy!
Sing to you at night?

 Peet Singleton.

Ruthless and painful.
Like a cat raping a dog.
I will haunt your life.

 Thom Norman.

Haiku on my grave.
Look how creative I am.
It's a shame I'm dead.

 Ben Norman.

Boredom on the loo?
Solve this problem with haiku.
Or pistachios.

 Dan Broadbent.

Pastry in distress.
A pie should be tastier!
Tasteless pie bake-off.
 Peet Singleton.

Secret beef I keep.
Close to my heart. Warm and soft.
Slightly hard. Secure.

 Thom Norman.

Started in nappies.
Did some stuff in the middle.
Died in nappies.

 Ben Norman.

On-going account.
Little pieces of my mind.
Set out on paper.

 Dan Broadbent.

Bond in a rucksack.
Jude Law sleeping next to him.
Oh, the nights they had.

 Peet Singleton.

One down is one up.
On people that are two down.
Simple mathematics.

 Thom Norman.

Too much Cabernet.
Get this wedge off of my head.
Blue-lip pillow stain.

 Ben Norman.

Churning out poems.
Finish a haiku with style.
Pink nipple tassels.

Dan Broadbent.

Facebook bollock-head.
Mark Zuckerberg drinks info!
Give him your cock size!

 Peet Singleton.

I feel overcome.
I fancy something Asian.
Something small and sweet.

 Thom Norman.

No jobs for anyone.
Fat tory reigning supreme.
No, it's not 1980.

 Ben Norman.

I am who I am.
I won't change for anyone.
Have faith in one's self.

 Dan Broadbent.

North, East, South, West, up.
Down, left, right, forwards, backwards.
Wind, Air, Fire, Water.

 Peet Singleton.

I ran for the moon.
Not slowing for the white light.
I ran through the moon.

 Thom Norman.

Helmet, light and axe.
Fingers are white, lungs are black.
'Where is my desk, Sir?'

<div align="right">Ben Norman.</div>

Sophie's cat ate shrooms.
It foamed from the mouth and bum.
Not a fun-guy now.

 Dan Broadbent.

Tiny kangaroo.
Wobble my board bearded one!
Time waits for no man.

 Peet Singleton.

I can't write haikus.
I don't have spell check you see.
On my mobile phone.

 Thom Norman.

What do we have left?
Coffee, Gin and a Parsnip.
Oh well, if I must.

 Ben Norman.

Broken dreams lay hard.
One day I'll wake up happy.
As for now I'll wait.

 Dan Broadbent.

My mind is an egg.
My foul lips are yours now Goose!
Go away, gander!
 Peet Singleton.

Dire experience.
One distracts from the other.
Sartre whilst pooing.

 Thom Norman.

All applicants fail.
Hopes of prosperity die.
Please hand me the rope.
 Ben Norman.

5 is half of 10.
7 is lucky for some.
5 a side football.

 Dan Broadbent.

HAARP is a weapon!
They change the weather with this!
Blue sky turns jet black.

 Peet Singleton.

Can't think what to write.
Just making up the numbers.
No sincerity.
 Thom Norman.

Friends with everyone.
A social chameleon.
You will not fool me.
 Ben Norman.

I'll never grow up.
Childhood is always better.
Love from Peter Pan.

 Dan Broadbent.

Provide me with snuff.
Grab my balls and contort them.
Fate decides your fate!

 Peet Singleton.

Torn lungs, heart beat ears.
The cold pavement my cradle.
I can touch the stars.

 Thom Norman.

One mans excellence.
It will not be enough.
If it's not shared.

 Ben Norman.

Such small worlds collide.
A friend's, friend's, friend's, friend's, friend's friend.
6 degrees theory.

 Dan Broadbent.

I know who I am.
Wait! I forgot who you are!
My teeth feel like ice.

 Peet Singleton.

Back to the future.
Don't be rude. Turn and face it.
Or it may fuck you.

<div style="text-align:right">Thom Norman.</div>

No words are spoken.
We're on the road to nowhere.
As David Byrne said.

 Ben Norman.

The power of words.
Is an interesting thing.
Be considerate.

 Dan Broadbent.

How many roads must?
How many roads don't? Don't know.
Answer me dear lord!!

 Peet Singleton.

Wash the chopping board.
Surprise morning garlic bread.
Is not a good start.

 Thom Norman.

Kids out of the way.
Lynx lager, the escapist.
Stop asking "what's wrong?"

 Ben Norman.

A wise man once said.
I can count my real best friends.
On one of my hands.

 Dan Broadbent.

> Tales are but stories.
> Fables are but hymns for gimps.
> Give me a real truth!
>
> — Peet Singleton.

Train station limbo.
Fuck this! I will jump the gate.
It seemed logical.

Thom Norman.

Your face insults me.
Words fall from your mouth like teeth.
It's a shame you breathe.

 Ben Norman.

I am a good man.
With wild thoughts and ambition.
Love all the people.

 Dan Broadbent.

Boring little witch.
Go get a life little witch.
Shut the fuck up witch.
 Peet Singleton.

You are included.
Just not credited at all.
We've stolen your work.

 Thom Norman.

My mistakes are made.
'Just allow me one more chance.'
As Bob Dylan said.

 Ben Norman.

Think positively.
Don't act too negatively.
Love.Hate.Win.Lose.Die.

 Dan Broadbent.

Chinese cracker boy.
A human fortune cookie!
Heed his wise words well!

 Peet Singleton.

Weathered, rough and wise.
Like an old dog with a limp.
Dad keeps plodding on.

 Thom Norman.

Marshall McLuhan.
It all happened after all.
You owe Tim a pint.

 Ben Norman.

I just want to do
Something I love with someone.
Who also loves it.

 Dan Broadbent.

God in a toilet.
He ran out of toilet roll.
I shopped and bought some.

 Peet Singleton.

Unlike Leverson.
I refuse to censor.
This line is censored.

 Thom Norman.

Top of the food chain.
Lemon, thyme, carcass & stove.
Eat meat, you're meant to.

 Ben Norman.

100%.
Adamant she was the one.
Volkswagen Polo.

 Dan Broadbent.

Cop that you dildo!
I dream to view your nightmares.
Checkmate, marble balls!

 Peet Singleton.

Watch held to my ear.
The echo of a second.
Remains once its gone.

 Thom Norman.

Discarded Chapstick.
Lone man wanders with dry lips.
Why did he leave you?

 Ben Norman.

Solemn thoughts ache deep.
Eyes wide, mind is fast asleep.
Stuck in twilight zone.

 Dan Broadbent.

Egg cartons are that.
A place for unborn chickens.
Pop them in your gob.

 Peet Singleton.

Read the second line.
I live to watch you exist.
The best I've written.

 Thom Norman.

Sugaring the shit.
Poetry from the mundane.
Say it with Haiku.

 Ben Norman.

Should I accept her?
The question I ask myself.
Facebook limbo girl.

 Dan Broadbent.

Football is ok.
Ping-Pong is ok, sometimes.
Croquet is just shit!

 Peet Singleton.

My hair is perverse.
Like a man with textbook tits.
Intriguing but wrong.

 Thom Norman.

www.ingramcontent.com/pod-product-compliance
Lightning Source LLC
Chambersburg PA
CBHW072222170526
45158CB00002BA/712